Andrew Johnston Davies

THE COMMUTE

Earthen Tones Publications

Earthen Tones Publications, Unit 50807,
PO Box 6945, London, W1A 6US

First published in Great Britain in 2020 by Earthen Tones
Publications

Made and printed in Great Britain

www.andrewjohnstondavies.co.uk

THE COMMUTE

Andrew Johnston Davies is a psychiatrist, artist and author based in Hampshire.

Whilst the countryside remains his natural habitat and the root of his artistic inspiration, he ventures into the city on a daily basis where urban landscapes, strangers and the commute have all become familiar images. Themes that explore disconnection, alienation, loneliness, love and loss. The Universal themes of life.

Andrew states that "Art is the drawstring that brings the different strands of my life together and yet for years it had been a private affair with writing kept within notebooks and images kept within drawers."

This all changed in 2019, when the Argentinian magazine La Tundra selected his writing and images for publication, after which point Andrew was inspired to complete The Commute and make Art, poetry and prose a serious pursuit.

www.andrewjohnstondavies.co.uk

Acknowledgement

I acknowledge with gratitude the friendships and conversations with my fellow commuters over thermo-flasked coffees on all those cold mornings.

A.J.D.

To my dearest family,

My parents Ron and Sarah for their love, support and their belief in me. To my wife Milica for being a true life partner and having the vision to bring this project to fruition. To my children Lily-Rose and William, may you find and explore your own creative paths,

with Love

CONTENTS

Preface

THE JOURNEY IN

THE JOURNEY OUT

PREFACE

To travel brings the scent of the unknown and the allure of coming to know what might lie just beyond the blue horizon. To commute, however, is a different kind of travel, one that is forged instead out of repetition and symbolises the daily grind. Beyond a certain point, a certain duration, it is no longer just a journey to work but morphs instead into a beast that can devour you piece by piece. It takes up time in your life. The only life you will ever have. The relentlessness, the repetition, the mundanity, the obligation, the chore. It is the well-worn groove of sufferance, backwards and forwards through rush hour commuter trains, buses and tubes. The impassive stare of the stranger. The loneliness.

The commute becomes imprinted upon you and leaves its mark. It is a reference point against which other things can be measured. You can begin to see the details of the world and become a witness. A witness to how things change, both internally and externally. The reiteration of the same narrative across the four seasons and over years allows such observations to be made, each day measured against the last.

As for the people, the commuters themselves, they journey into and out of London just as others do to any other town or city up and down the country. Flowing in and out like blood cells, passing through vessels into the heart which pumps them back out once their work is done. Each person a small cog within this vast machine-like society that somehow works most of the time.

There is a sense of common purpose, of being part of something far bigger than ourselves, part of society, part of humanity.

Day in day out, regardless of the weather in the sky or within our minds, we get up and head for work. There is a stoicism in this, under recognised and unheralded, which these pages can only hint at, through this patchwork of a journey, stitched together across time, unfolding as if a single day.

The journey to work and back. The commute.

The Journey In

Insomniac demons

Sleep
that fragile vine upon which I wither or thrive
Where the insomniac demons descend
Down into the depths of night.
Howling from the shadows
Whispering from the hollows
Crawling and swarming over nidus of doubt
Stripping away at the shrouds of sleep
like vultures tugging at skin.

Restlessness wakefulness, whirling vortex
running untamed, spiraling within,
I count and recount the dwindling hours
until the dawn light creeps in.

There are pockets of calm of course
to tantalize and tease
to lift me up on a tide
to the very cusp of sleep
but they leave me there stranded, condemned to listen
to soft breaths all around me,
of those who sleep so soundly
how sweet must be their dreams.

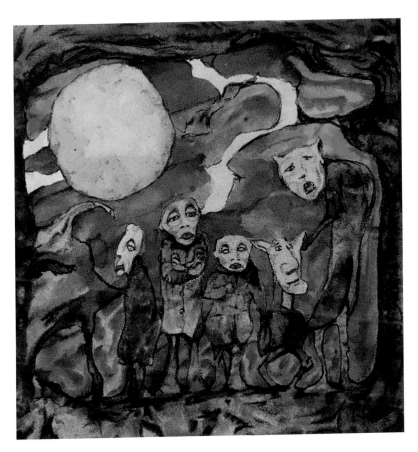

Up to their old tricks

The train waits for no-one

Outside is dark and quiet save for the rush of an early car
Houses shut, curtains pulled, no-one stirs save for me
The air is crisp, I pull my coat close as my feet crunch upon frosted
grass and again upon the gravel.
Morning sheathed within night, dawn not even a whisper
only the Moon's pale presence, the face of eternity
a companion of mine on these lonely mornings
its calm and ancient rhythm etched in our souls.
The sea of serenity, whose still waters lap gently to the lunar breeze
up onto the white dust shore.
The sky is clear and the Moon crystalline,
it is enough to see me through.

The garden is pooled in the shadows of shrubs, stalks and dead
plants
broken and twisted like wreckage upon the fallen leaves.
I see the last rose has gone, leaving only the weeds behind
yet like dim points of light, tucked in by the hedgerow,
snowdrops glow,
a shivering sign that something stirs even within this frozen night.
Winter's hold will break, life will start anew
until then though there reigns only a darkness
more the time for bats, mice and foxes
yet here I am as the family sleep, young, quiet waiting for morning,
I leave as the clock ticks, the kitchen clock, the car clock, the
platform clock.
The train waits for no-one.

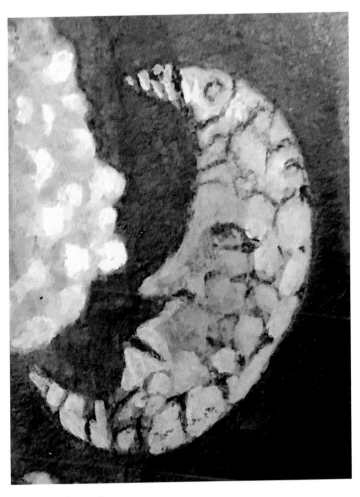

The Face of Eternity

Winchfield

The lane to the station slides off the old London road (A30) heading past fields where only mists lie thinly spread over the dank earth. Sometimes deer graze, half hidden within misty veils. The Old Potbridge road heads off to the right, a blind alley dissected by the motorway. In the summer months the lane billows with shifting boughs of summer green, beyond them are the hidden shadows of woodland and still further lies a lake hidden from the road where once I stood amongst the slender trees watching the early Sun gilt the western shore.

Winchfield station is the first true rural station along this line from Waterloo. A humble affair, small and brick built in 1837. Inside is Clive the stationmaster, sitting low on his stool, particular and precise with sage train advice for those who need it. Opposite him stands a table spread with books from which you can take or donate to. Further up the platform is the small room from which Diggy sells coffees and teas as well as the morning paper and so sets the routine for many.

Summer has gone and the English autumn is here with a certain coldness to the air. Children have returned to school, the leaves have turned, and the geese fly over in squadron formation. Coats are in use again and the hot cup of tea is welcome, succor to this chill.

Fiery Sky

6.35 to London Waterloo

Like grains of gold fine rain comes down,
drifting in on the wind,
past the platform light,
settling bejeweled upon the subdued ground.

Here stand the commuters,
lone souls on barren mornings,
scattered down the length until the light runs out.
Within this lonely glow these statues stand upon their usual spots,
warm beds missed,
just as they did yesterday and will again tomorrow,

Then suspended in the half light
Less than a pinprick
where the line runs straight and true
ever more defined
coming in from the west
the 6.35 to London Waterloo.

Grains of Gold

The Morning Star

The platform roof is held up by cast iron columns. The
second to last one, on the right, is my spot. Everyone has
their spot and we tend not to stray, if we do it is noticed and
eyebrows are raised. Next to me is Jeremy my old friend,
6 foot four of him, who still does the village cricket fixtures.
Fi will come along soon from over the road, tea in hand.
 Jack used to be here too but he and his white walrus
moustache have sidled off into the sidings of retirement.
I still see him in the village.

Tom will wheel in on his bike just in time wearing shorts
whatever the weather, whilst Johnny will arrive
with that glint in his eye as if he's just had a quick smoke
behind the bike shed.

Jeremy listens in the darkness "Did you hear it?" he hisses,
 " Hear what?" I whisper.

"A duck" he explains. I hear only silence. I stop breathing so
as to detect even the faintest of sounds. Time passes slowly,
until, sure enough, far from any pond there comes a distant
and muffled quack. Jeremy nods and smiles.

We wonder is it Venus we can see just above the tree-line.
The morning star.

The Journey

The 6.35

Slowing in the last yards the train draws in to a halt and so we board and find our usual seats just as the express train flies by. The train heaves forward, pulling out into the blackness leaving behind the soft glow of Winchfield.

Winchfield to Fleet

Between Winchfield and Fleet there lies a dwindling strip of countryside that clings on against the encroaching urban invasion that threatens from all sides. Winchfield is marked down within the Domesday book and begins here with a broad sweeping field across which a line of pylons march and upon which rabbits dwell unconcerned by our passing.

Above there hangs a red kite searching over smaller, humbler fields that pass with the twists and turns of hedgerows, fences and field gates. Hawthorn, hazel and spindle, fields of corn and fallow fields of scratched and thistled grass. An understated beauty that holds on to its secrets.

Into the distance

Within the Memory of Earth

The clouds hang low,
almost within reach,
as if I could stand and push my hand up within their midst.
The daylight, if it can be called that, is thin and sparse
cloaking the fields in muted colours
hushing our voices
to deeper silence.

The field to the north lies fallow,
dotted with islands of coarse grass
passed through by tractor tyres
gouged trenches left
holding water from this saturated land
that mirrors the sky,
lying pale between the clods.

Held in these fields,
is the memory of earth
the humble toil of men who served this land
by plough and scythe
so that it in turn might serve them.
Ploughed furlongs and ribbed lines
known so well to those who once knew these things.
Over in the distance, further than the blackthorn hedges
but before the down land,
lies woodland,
dark and barren.
And from within those trees rises a thin trail of smoke
as if from a woodman's stack
a ghost lost within the morning.

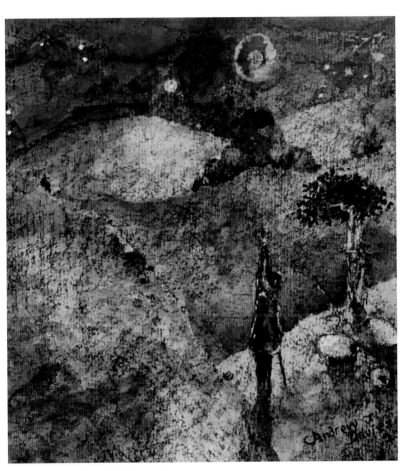

The Shepherd Watches Over

Spirits

In August the air is heavy and close. The rains of yesterday rise as spirits, vapours returning heaven bound from whence they came. The clouds have passed and the raindrops have been absorbed by the earth as the Sun now smooths away our troubled minds.

Pirbright Junction stands as a solitary sign, like a remote outpost. A marker of some kind as if something was once planned but never happened. All that remains now is the sign.

Moonstone of Pale Yellow

By September the Sun rises ever later as summer fades back to embers. The Sun haloed and haunting, a moonstone of pale yellow, barely with strength enough to pierce the morning veil and yet suffice to light particles of dust like fireflies, floating within the shafts of light. Soon the Sun gains a strength so that it can no longer be looked upon as the mists are reduced back to whispers.

Within a wood a house is almost hidden. Close to the trackside a heavy laden bough spills down brown and yellow fruit, tumbled to the ground in rich pungent decay, where the wasps will come and gorge drunkenly as the Sun warms the day.

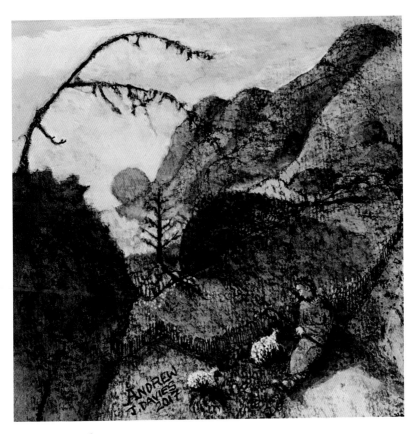

At the day's end

The Soft and Fragile Webs

We sit within a cutting for long minutes,
with no explanation given for our stay within this still
valley. The banks rise high obscuring all
but the banks themselves,
dressed in ivy green
and pierced in places by shoots as the new bracken unfurls.

Up on the brow
the first rays of light touch down
catching the dew
held within the soft and fragile webs
that lie between the blades of grass,
glistening jewels of light
within these first moments.
Without warning the train moves
and so we leave this nameless place in peace
to prepare for its morning.

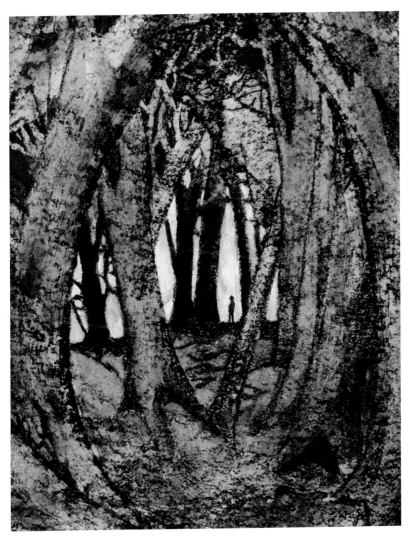

There is a way through

Woking Station Platform

6.57 and 15 seconds
Two young women sit opposite
their voices babbling beneath reflected light
sourced from an endless wellspring
heedless to the silence that surrounds them.
They empathise with one another,
For having to rise so early in the morning,
oblivious to the wry smiles
of the battle-scarred ones, the weary ones,
the commuters who keep on keeping on.

They commence a review of last night's text exchange
between the pretty one and her new boyfriend.
They sit, heads bowed,
scrutinising, scrolling, reciting, analysing
until the denouement comes
"Is your bath big enough for the two of us?".
"No way!" snorts the shorter one.
The cheek of it, she seems to say whilst scarcely hiding her envy
Not to be outdone she relays her own, underwhelming date,
a "chavvy boy" who took her to a "chavvy pub" on the outskirts of
Woking
his shirt buttons undone, his spindly frame displayed
"button it up" she had wanted to say but didn't,
too polite she explained, not wishing to crush his probably fragile
ego
yet he was sweet and she wonders still whether to say yes or no?
but the question has no answer and is left to hang in the air
as they both spy their station
and they both make to leave.

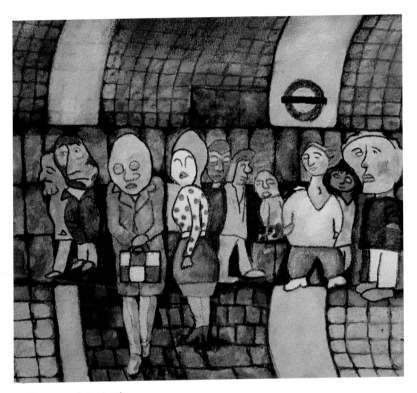

Underground Gathering

Tickets please

"Tickets please ladies and gentleman, boys and girls" as the conductor sweeps down the carriage, spectacles jauntily perched upon his brow. A wave of hands fumble and seek out tickets lost within bulging waistlines, pockets, bags and coats. The daily ritual as each ticket is retrieved, displayed and then peculiar to this conductor, is responded to uniquely in turn "Fine, cheers, super, thank you, champion, sweet, spot on, dandy, nice one".

The train flies, past flickering signs, a single shot image of commuters upon a bleak platform. Dozens of them standing there, still in the dingy light. The rain begins, battering the windows like background static. Shadows, street lights, lonely platforms, horizontal beams of light. A man tries in vain on his phone, but the reception comes and goes, his voice stops and starts. He tries again, mistrustingly "I'm in the quiet carriage" he drawls like a Harley Davidson ticking over. He goes on "You know you want to split, down tools, tired of obligation and phoney rules. You know it's your time ".

One of Them

Squeezed between strangers

I had no sleep last night. I don't mean poor sleep, I mean no sleep. Empty, hollow, staring eyed night, alone in the darkness as the hours drain away.

The train fills to standing. My head leans on the window. A man runs frantic down station steps two at a time. He makes it, breathless, thankful to the train gods who smiled down upon him this time.

I sit squeezed between strangers. My back is stiff and my knees ache. My bag sits heavy on my legs loaded down by books, though there is no need for these books. I brought them anyway, just in case.

London is here

We fly over the river Wey,
across the boundary line,
beneath the Orbital,
graffiti clad and concrete grey.

The noose within which the city lies
upon which the thundering cars pass
and above that the thundering skies threaten rain.
Beneath its span runs a sparse track that turns sharp by the
waterway
a man walks there, his dog up ahead in brambled wasteland,
past the strewn rubbish of plastic, bags, and tin cans.

On the outskirts of town,
Where the hedges have stopped and the suburbs lie,
houses, row upon row, in battalions,
pierced in places by spires, churches, cranes and powerlines.
In the shadows lie backyard strips, empty trampolines and tiny
sheds
gardens diminished almost to nothing,
the city has come
London is here.

Next Stop is Clapham Junction

Clapham Junction slides in all grey, drab, multi tracked and platformed, not pretty but functional, a ceaseless activity of trains either drawing in or drawing out and people who are either standing or rushing. We will join these comings and goings as we stand up to leave. The knees of others politely withdraw as we extricate ourselves from our warm cocoon seats. Jeremy, myself and Gordon from Fleet, as well as countless others emerge at 7.24.18 seconds displayed in orange lit numbers above our heads on the platform clock. "It must get harder this" mutters Jeremy as we trudge amongst the trudging crowd. "You know, as you get older, the routines, doing it all again and again, it gets harder". We reach the top of the steps and head our separate ways.

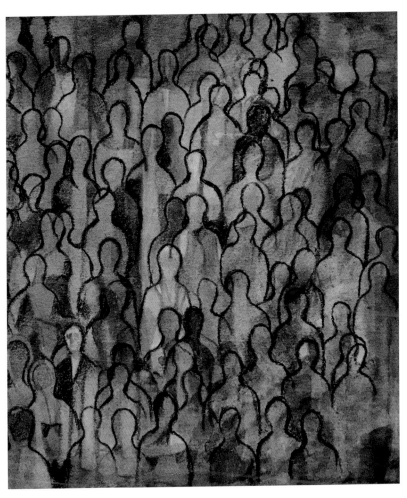

All of us, Waiting

Train to the coast

Frozen air penetrates deep into the enclosed bridge
stretching over rows and rows of track.
Steps head down to platforms,
Where the trains come and go,
Announcements echo.
Streams of people flow
in pulses,
absorbed within their own worlds,
busy, rushing, avoiding others,
off to connecting trains and off to work.
The smell of garlic is thick in the air by the station cafe.
A few huddle around plastic tables,
supping steaming cups of coffee.
There are no frills, no sterile modernity,
I can almost smell the smoke of steam trains pulling in and pulling
out.
The Portsmouth harbor train, the Salisbury train the one to Alton
I get the urge to pull out too,
to break away from this work bound inevitability
to catch a train to the coast,
to see a shingle beach
to hear the rush of waves,
to skim stones in spitting rain.
It would be cold and we would feel it,
We would sit in a solitary bus shelter
we would find a café by the waterfront, lace curtains pulled to one
side,
an elderly couple by the window watching the incoming tide
we would listen to the swash of the sea wash the pebbles clean
Only after all of this
Would we return home.

Tranquility

Oblivion

Outside the station where the taxis stay it gets darker with every drop fall of rain. Propped up by a wall a wheelchair leans abandoned and forlorn, locked up by chains and upon black leather the rain begins to drum. Down the steps to the roadside I wait by the traffic lights where a pregnant woman sips red bull from a can, beside her, her son tugs and whines until he gets what he wants and then stares into the oblivion of a screen until the lights go green. We all cross and head down to take our place and wait for the bus.

She's got the upper hand

Steel upon steel

Beneath sheet metal skies of uniform grey,
work hardened faces stand against the mists of rain

It can be bleak here by the street-side
raked by the rasping wind
there's little shelter
save the doorway of the Army Centre.

 'Territorial', the word, has long since gone,
 only a ghost trace remains,
 stenciled in by the stains of city air.

A pigeon stands clawed to horizontal mesh,
pecking at a drumstick that dances to every peck.
In the distance I still hear the trains
the constant clattering refrain
the shriek of steel upon steel

Another pigeon comes missing a foot,
Squabbling and pecking in last night's sick.
A street cleaner comes with a high-pressure hose
to transform all before him into fine aerosol
Yet, even then, it drifts and hangs in the air
all we can do is hold our breath and wait.

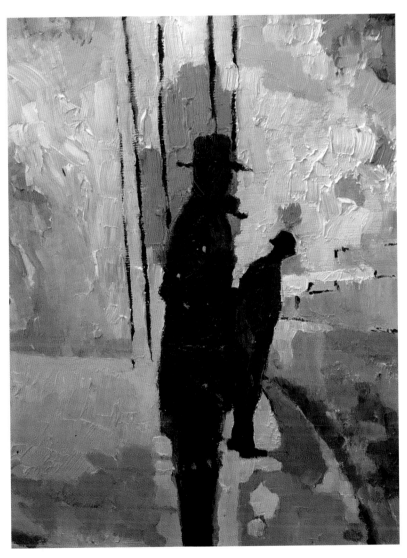

Is That the Bus?

A Single Red Rose

Territorial Army Centre
Imposing darkened brick
Looming by the side of the bus stop
Wrought iron railings layered thick with decades of paint, chipped
showing the years like the rings of a tree.
A banner hangs limply over the old front door
Of bright young faces
Designed to lure tomorrow's soldier.

But today the railings are adorned with flowers,
Hundreds of them,
small cards attached, messages within

And amongst all of these flowers,
all the noise of colour,
there is a single red rose
I read only the first line
for these are the words written by the hand of a mother.
Not meant for my eyes
for she spoke of the loss of her son
of how hard it is to bear that loss
and to have to let go of his hand

A week later all the flowers have gone
though the railings remain,
still thick with paint.
The building looms and the bright shining faces still look on
I continue to come,
as do all the others.
And life just carries on.

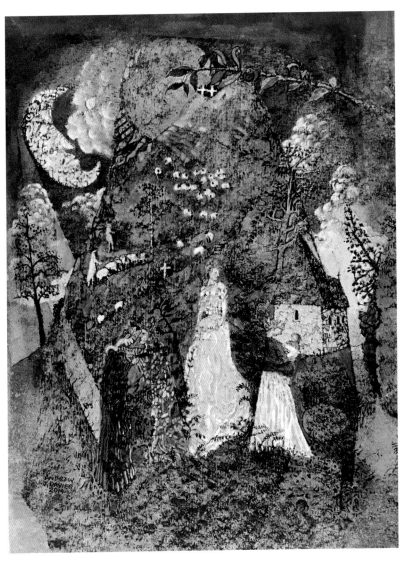

Winter Rose

Workmen at dawn - The 295

Workmen at dawn board the bus,
track-suited and booted,
woollen hat wearing,
paint splattered,
with grizzled and sombre faces.
A few are still young with mouths closer to a smirk.
Spirit level in one hand,
sausage roll in the other,
they board the bus,
all headed for work.
From the top deck
I look down the angle of the blind
into a front office
and see the face of an angel
dimly lit by the pale light of a computer screen.

"This is the 295 to Ladbroke Grove Sainsburys"
announces the automated voice.
The bus driver slips it into first and the bus trundles on.

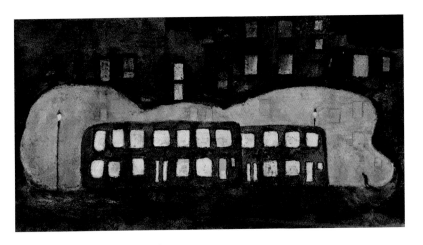

295 to Ladbroke Grove Sainsburys

Lavender fields

Lavender fields

yet there is no sweet smell,
no haze or dust,
no collection of the harvest.
Only the road sign,
less than a memory
of what had once seemed endless
as if nothing ever could change.

I sit in a bus,
and the bus sits in a queue
and the queue sits within endless roads and streets,
Tarmac, pavement and concrete
cars and vans
a gymnasium of people,
straining every sinew
fast food packaging, cigarette butts
and chewing gum
pot marked and stuck to the ground

People traipsing to work
on the end of strings they can't see
by evening time they retrace their steps back to their homes
numbered neatly
within streets named as if meadows
but there are no meadows, none that I can see
instead I sit here, in the bus
and the bus sits in the queue
and the queue sits within endless roads and streets.

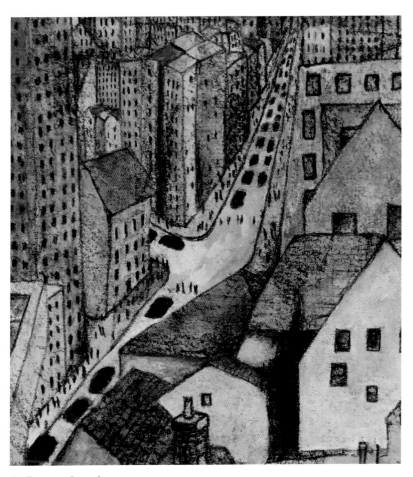

Endless roads and streets

A Little Baby

"Kerry's got a little baby now, Caitlyn's got a little baby now and I've got a little baby now! We've all got little babies, isn't that incredible, to think we're all mums, I can't believe it, and when Julie has her little baby she'll also have a little baby" came the voice of someone who has recently had a little baby.

Peeling Open

Running for the bus the lady doesn't know the zip of her bag is unpeeling under the weight of the documents. She does not notice the first loose leaves flowing out as if in slow motion, spreading across the pavement, flipping and skipping in the breeze as if in giddy celebration of their release. She runs on for the bus still unaware.

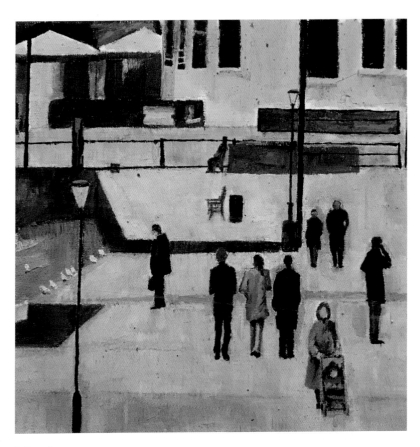

Waterfront

Pink Fluffy Slippers - Strath Terrace

'Strath Terrace'
announces the 295's bus voice.

In the dim light this seems a gritty place
although a warm glow comes from the corner shop
spilling out over fruit and veg displayed in crates
stacked up upon the pavement.

Beyond the shop, shadowed in the background,
city blocks lurk as if lumbering giants
but they are no more than the homes of hundreds of people,
young and old,
people just getting up,
children pouring milk upon cereal
or their mum trying to prize them from bed.

Outside a doorway
an old woman stands alone,
smoking,
swaddled in a bath robe of flamingo pink plumes,
her thin legs rooted in fluffy pink slippers.

Salon tanned,
burnt and roughened at the edges
she drags on a cigarette and blows out smoke
as she watches us pass by.

"This is the 295 to Ladbroke Grove Sainsburys".

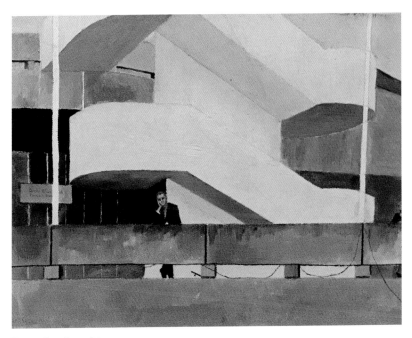

Pause for thought

Discarded

A large scarlet sofa has been left sitting on
the pavement next to a recycling bin. You
could sit there and watch the day go by.

A Throwaway

All things pass

Things change

It may not seem so at first
not across the early months, or even a year
but then you begin to see,
the progress

A Victorian house stood here
beside a church.
An austere grandeur even grace
A walled garden not so worn it couldn't have been saved

I had hoped those walls would have been high enough
To have kept the world at bay
to have remained unnoticed
to have remained unchanged

I saw its destruction in ticker tape timing,
one slice per day,
Within the week the tiles were off
and the house stood de-robed of skin,
rafters exposed like the ribs of a carcass
a great ship in helpless salvage
or a whale harpooned with pins

Brick by brick, stripped
Until the sunlight shone in

By the turn of the week the house was gone
replaced instead by broken brick,
splintered wood and slate
and even those heaps were scraped clean
with new trenches laid, from out of which grew columns,
either shoots of hope,
or gravestones,
I don't know.

Three cranes hang still
suspended like bodies of insects'
unblinking compound eyes.
A building emerges, with gleaming surfaces
and a slick billboard sign.

New luxury homes,
a marketing suite and crayon green grass
temporary shrubs in tubs
Wooden signs on wooden posts hammered in, bearing words
"live your life your way"
"your life in your hands"

But I still remember the old house
It once stood there beside a church.

An Angel Watches over

Great Chalk roads

Up on the top deck
people sit huddled in puddles of coats and scarves.

I feel so tired,
My health splutters in fits and starts
held together by wires and threads
my head vibrates on the window pane.

It's that time of year
That time of life
when niggles become chronic and ailments routine.

I've seen the incoming tide

The one I thought might never come,
Yet now it quickens

Above,
the sky is cerulean blue,
Almost too beautiful
criss-crossed by contrails that traverse like great chalk roads
drifting and fading on the wind
out of reach of the living
roads on which our mortal souls will walk

to their empyreal end
there are no lucky few
no one is spared
that day when our tide comes in.

Out of reach

Coat and school bag flapping

Rounding the corner the boy bursts a lung running helter skelter with all he's got, coat and school bag flapping and yet all is in vain as he comes skidding to a stop, just too late. The bus has left and he endures the ignominy of friends on board spying his fruitless dash.

I hear them laugh before they drift back to idle chat. They don't notice the distant figure has started to run again. Past the post box he runs, past the shop fronts, the hedges and garden gates, passed the For Sale sign and recycling bins even as the bus rumbles on devoid of all sentiment.

It is futile it would seem, yet I admire him nonetheless for not giving in, not throwing in the towel, his spirit continues undimmed. The traffic congeals to a glacial pace and the boy makes ground, becoming more than just a dot.

I can see his face now, the school bag and the flailing limbs. The bus trundles on but he's done enough to make it to the next stop, this time boarding the bus with cheeks flushed and heart pounding having won the admiration of all his friends.

Meadowbank Heights

Tower Blocks

Two black crows

Through a spy hole,
Through steamed glass
I see a signboard by the riverside
That points both ways
to the source and to the sea.

The river breathes,
like great lungs
that rise and fall
shifting vast volumes
shining like a thousand silver suns.

Yet today that light has ceased
instead a fog lies like a fox
quiet upon the Thames
snuffing out the long views up and down its reach

A digger looms idle by the side
Of a tilted barge, cavernous and dark
its chain trailed down to the gravelly mud
as the tide remains
neither in nor out

Across the bridge
streetlights shine like pale moons
at the midpoint, the bus sits marooned
sightless of both shores
no beginning and no end.

Out of the void
comes two crows,
Sudden, black and distinct
I see their wings beat,
their crows feet
sharpened beaks
a portent that passes over and flees
as if knowing something we don't know
they make for the sea

Into the scrum

A Barefooted Soul - Tyrawley Road

The sunlight falls gently upon a man who sits on the pavement close to the corner of a side street on the left. It is as if all the traumas of the night have passed and now the Sun heals and soothes this barefooted soul, his legs splayed out and his back leant up against the brick wall. The elements have worn his face, sculpted his bones, yellowed his hair and beard, his features lit by the morning sun, his ruddy cheeks and nose bright against the shadow. He seems peaceful in his disheveled clothes as he watches people pass on their way to work. The beer can next to him casts its shadow over him.

A Bag of Potatoes - Shorrolds Road

From time to time you might see a shoe, a book or pencil case flung up from ground level sitting upon the roof of a bus shelter, but I have never seen a bag of potatoes before. They sit there for weeks, an erratic, out of place. The potatoes germinate and programmed for life they send out pale shoots searching for sustenance. I already know their fate, the futility of it all, yet it has to play out day after day, until all hope has gone and then the end is reached.

Deciding the fate

"You Know it's a Good One"

"Cold? Oh, it's lovely, it wakes you up, makes you feel alive! Very Christmasy. Definitely it will snow soon I think. You look familiar, do you play footy? Did you play for Barnes? What's that? Southfield club? I played two games for them, a long time ago, do you remember Ed? No? When did you play? 15 years ago? I was about then. I still play even now, though I'm forty odd, I can still play with lads in their twenties. I'll put in a cross and you know it's a good one, and they don't get it, but you know it was a good one, you know what I mean? How frustrating is that when you know it was a good one".

I feel for him, how that moment came and went, unrecognized, without comment, life's great shrug of indifference suggesting that no one really cares. Yet somebody does care as his phone beeps with a text message. "That's my bird saying good morning, she always does this every morning, she likes to know what I'm doing, I'd better just say hello. She's English, you know, completely English. I mean I'm English too but with a few drops of Jamaican rum, you know what I mean? Have you got kids? Oh that's good, that's what life is all about. I've got kids, I see then every two weeks. I'm older now, 44, but when you're young you think you can go about and do stupid things and come back and it'll all be ok. It doesn't work out like that, you've got to respect each other, that's the key".

"What's your name? Jason? Nice to meet you Jason. What do I do? I clean windows, 38 shops today all up Hammersmith Broadway and aroundabout. I'll leave Putney till next week. It was my old man's business, but now I do it but I have to take the bus cos I can't drive cos of my condition, can't concentrate you see. Alright Jason it's my stop, nice talking to you Jason, you take care now".

A Scraping Sound - Munster Road

The electrical store has closed down. All that remains is a
scribbled message on a scrap of paper stuck to the front
door for customers to read. I will no longer see the shabby
man, the one who used to stand outside the door, with his
hoary curls poked out from beneath his earthlike hat,
shifting side to side, foot to foot, smoking a cigarette, at the
butt-end of life. He would stand there waiting for the key-
holder to arrive. I stood next to him once on a bus. The day
of a tube strike. He reeked of smoke and cigarettes, his
cough rumbled deep within his lungs, a scraping sound
marking out time with every scrape.

Roving eye

I see the side of her face
Worn and bronzed
her eye framed by a circular mirror
her finger poking, prodding
sixty years worth of skin
Every line, every furrow
Every pit, every hollow
like a creased map
of familiar paths and sunken lanes
all to be traced and filled in

Streaks of paint and Polyfilla powder
applied with a liberal brush
balancing and jostling, rolling and jolting
occasional shouts at the oblivious bus

When she is here she has a certain flair
An eccentric energy
and a musty scent that hangs in the air.
Her flustering flourishes of platinum blonde hair
the loud pronouncements made on her phone
something tells me she lives alone.
She's unusual, even strange
her twitches and quirks belie some kind of pain

I won't ever know much more than this,
for when I go, she stays
still aboard the bus,
heading off to another day.

One amongst the crowd

Paradise

I walk the last stretch
Half a mile out
past Paradise Crescent
and streets to the left
past the recreation ground
edges fringed by empty trees
clutching to the last of the stubborn leaves

I see mud patches in the goal mouths of the weekend pitch.
On the far-side is a bench, dark, wet and derelict.
And two figures stand in the steady rain
a man and his dog.
He smokes a cigarette as he arches his back to throw the ball to be fetched.
The dog chases,
again and again like an echo
each time retrieving as if for the first time
leaping and catching on the apex of the bounce.
It returns triumphant, prey in its mouth
as if life always had been leading up to this
two figures
in the steady rain,
in the recreation ground

I arrive at work by 8.

The Outsider

Turning of the Day

I saw the sunrise
I saw the sunset
The sky was dark when I came and dark when I left
A sunrise so pure
I stopped my routine to see its splendor
The Sun half peering over rooftops and chimney pots
Shining its riches down,
I stood cradled within its light

Ephemeral, it could not last
But I could not bear to see it fade
I turned my back at its zenith.
So by evening time the Sun had fallen
Pale light to the west
There came a darkness from the east
The door closed behind me
I had seen little of the day
Save for this

The Worker

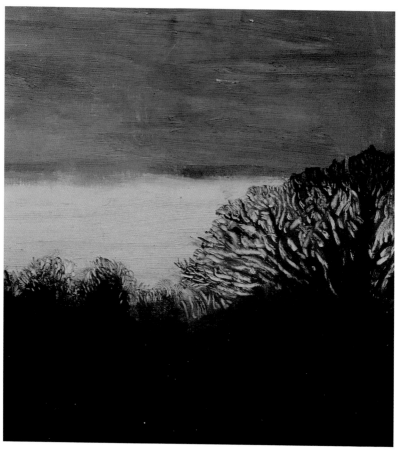

Sunset

The Journey Out

Wind

An invisible wind blows down Greyhound Road,
bullying gusts rush unannounced,
for Aeolus has unleashed his hounds and they stalk down this road
and the next.
There is no relief as the wind blows stronger
a newspaper cartwheels out from nowhere,
brushing past my feet,
across the road, down Everington Street.
An idle bag stirs from a sidewall rolling out like tumbleweed.
I hunch my shoulders against the cold and think of accidents,
freak ones,
tiles falling,
masonry cracking,
coming loose after a hundred years.
You hear the stories in the press, of some unlucky soul struck by a
brick,
a statistic in the local rag,
considered idly by a reader over toast and egg.

No not for me, not my death, not that death.
I scurry down side streets,
I hug walls,
I make time
I seek safety, shelter and refuge
down in the depths of London Underground.

Rain I

The clouds have gathered
marshalled into a brooding mass.
The taste of the air has changed
though still no warning for this
for the sky has opened up like the petals of the darkest flower
And from within its midst there comes a violence.
Pistol shots rain down, hammering upon open ground
my umbrella bursting, close to collapse
propped up by hand
as if a puppet
futile to this power.

Illuminated by streetlights and headlights
duplicated reflection
Raindrops glittering as golden splinters
drumming into skin,
clothes darken as blotting paper
shapes of walkers silhouetted by golds and silvers
Liquid downpipes gurgling,
funneling water in waves
over paving stones,
alive as mirrors, moving river systems,
watersheds and valleys.
Silver pinpricks upon molten glass
At last, within this city
I see the full face of nature.

Rain II

I try to keep under cover and adjust the tilt of the umbrella to match the slant of the rain. I walk in tight, short steps, keeping my legs dry, my shirt dry and socks. I hear the WHOOSH before I see it, but I turn in time to see a beautiful veil of water, like gossamer wings, lifted by a van from the puddle by the side of the road. Its cold embrace is swift and complete. No need to worry now about keeping clothes dry.

July heat, white heat

Two obese men, sit on buckling plastic chairs outside a café. "This armless woman, she stripped off!" said one, gesturing with a chopping motion onto his tattooed arm. His mouth opens with a toothless grin, snorting out a laugh from the cave within.

A black vested man with headphones stands on the curbside, bathed in pure heat, his hands are cupped and he yells "Yo!" to somebody, somewhere further down the road. A police car wails and pulls up alongside a young girl with copper coloured curls, sullen, handcuffed and well and truly caught.

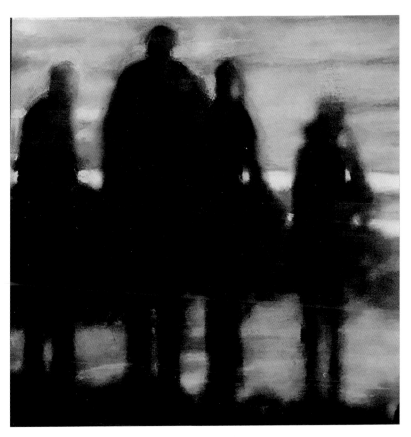

Rain I

September Sun-catchers by the riverside

Down the centre of the sky a plane cuts a crimson line, splitting it in two. The plane races as if it might still catch the fleeing Sun. But down below the river has darkened, the shadows have lengthened and air now cooler.

A half-submerged log drifts with the flow and I walk with it as if this might somehow stop time. But who am I to try and fool time, I stop and watch it go.

The plane has gone and the sky has changed, now showing only shreds and rags of the sunset's final splendour and the plane contrails are now stained smoky grey, teased out into wisps.

Two joggers pass speaking in staccato bursts. A vast crane pivots round as if a giant mechanism of a clock slowly being wound.

A whirring sound drifts through evening air as the crane's load descends and I watch until the ground is reached and then I go.

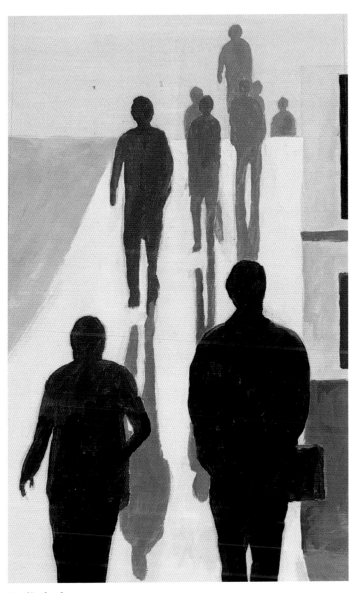

Sunlit shadows

Smoke and dust

I step out into the urban cacophony,
the city voice,
the flow of cars,
gears changing,
guttural rumblings of bus engines.
The smell of diesel in the air
Radiating vibrating heat
Conversations pass on the breeze
a car horn blares,
not to warn but to scold a white woman crossing the road.
Down the side street to the left
comes the clatter and roll
of skateboarders unseen in the low Sun
that blinds all who look down this road at this time
A free-wheeling cyclist glides by in a rush
I see a sunlit cloud of smoke and dust,
drilling stops and starts in machine gun bursts.
When it stops again
I hear my footsteps at last
as I come up into the Broadway.

Deep mellow

From out of the shadows
in Jamaican colours
the Rasta man steps out into bleaching August light.
Deep mellow tones from his saxophone
float on air,
melting like butter,
cocooning us in music
as we stand
waiting for the traffic lights to change
as mundane routine becomes sublime.
And time stands still
as if those lights may never change

He plays on beside concrete columns
close to a man who lies beside him, thin, white and broken,
aimless upon the ground,
like driftwood from a distant shore
mislaid here by the underpass

The lights change
the crowd crosses
Half in Sun, half in shadow,
he doesn't look up and they don't look down,
unless to avoid tripping.
Once they've gone, he remains
Forgotten here by the underpass.

MIND THE GAP

STAND CLEAR OF THE DOORS

From out of the train, passengers swarm out and become bulldozing masses by the exits. There is no mercy here only a dystopian survival of the fittest. Yet within this very same moment of despair, with a synchrony the crowd draw back, moving as one, a parting of the waves as a path is made clear through which a young woman pushes the wheels of her chair. She nods at the faces as she passes by.

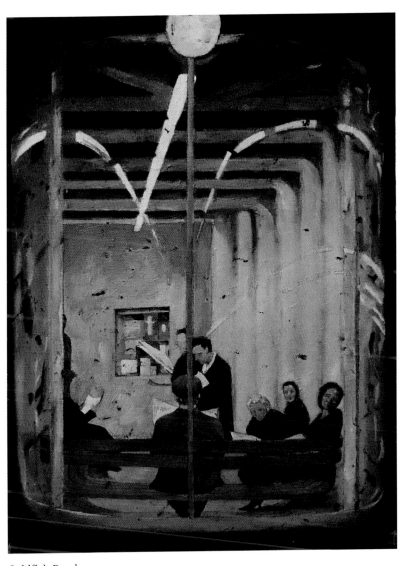

Goldfish Bowl

Two trains diverge

Deep Underground,
within London clay
encased by tunnel and train
held within dim mirrors,
are fragments of people,
indistinct bodies and souls.

The engine throbs,
the lights flicker
Tunnel walls are lined
by wires of dusky greens and reds
running in parallel until the wall falls away
and blackness descends, blacker than any night
yet it is here that the light comes of another train,
as life draws up next to life,
and like a voyeur I look in

Through the grainy screen of scratched glass,
Emerges a world of distant faces and marble eyes
Disconnection seems complete
Yet I catch the gaze of another,
For a fleeting instant
the recognition of a soul other than mine
and then she is gone
for the two trains diverge
and so we head our separate ways.

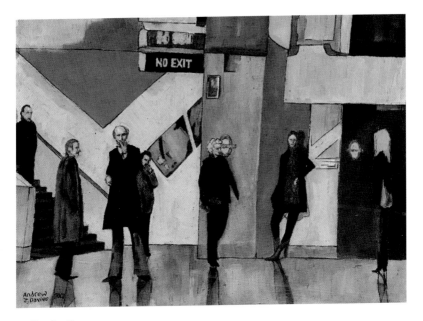

Strike the Pose

Picadilly Line - just passed Gloucester Road

A young woman wears clothes of beige and grey, her hair seems frayed and her face is long, pale and angular. She seems tense and begins to rock gently to and fro. Her hands begin to stim, flapping, with anguish upon her brow. I look away to relieve any pressure she might feel from my gaze, just to lessen any burden she might feel. It is not long before she settles down enough to pull out a book and begin to read.

Green Park - Connecting tubes and the depths

I've passed this way so many times, my footsteps might have worn a path, even a holloway. How many times have I been through this connecting tube between the Piccadilly to the Jubilee? A passage that reduces life to the chore of merely reaching the other end. I feel the limitations of our slow ambulatory pace that forces us to be patient. I contemplate time with each traverse of this sterile place each time marking out another day. One day older, one day closer. I feel robotic, an automaton. I hear the sounds and rhythms of people. The walkers, the dawdlers, the brisk ones, those who patiently wait whilst others are laden with bags and children.

Those in sleek suits, slick corporate types with odours of after shave and omnipotent boardroom confidence. There are women walking self assured with a sense of purpose and others less so. There are wearers of cheap shoes, mascara, ripped jeans and ripped torsos, others tattooed with a stud through their nose as others are respectably bespectacled. I can hear the clacking of wheeled suitcases, the brush of trouser legs, the click of shoes Then out of this disorder comes a moment of synchronicity, an alignment of some kind as if a universal rhythm is reached, that exists if only for an instant. From down the connecting tube comes the sound of music, a guitar whose vibrations resonate and lift us up and calm us to a meditative place. My body seems as if it is blown by a fair wind.

The music aids my passing. At the end I turn a corner and only there is the spell broken allowing the rest of the world to

rush in. The sound of laughter, a man pushing by, a woman who clutches her bag with each pale finger crowned in ruby red and one finger missing.

Out of the train and into the surging peopled torrent, a race to the escalators, shimmying down, flickering feet, lights shimmering on the side wall and steps glinting silver. Descending into a cavernous chamber as if it is an epicentre deep within a mountain. A temple of stone and we are the pilgrims. Indeed the walls are roughened as if hued from solid rock, the ceiling is pot marked as if by loudspeakers, the floor is springy steel giving bounce to every step. Nobody stays here, we all rush through as if hungry for more tubes and escalators, racing to the platform where the train seems always poised to leave.

In the carriage, standing, crammed, holding onto yellow tubed hand holds, surrounded by eyes, chins, foreheads, teeth, noses, ears, baldness, lipstick, the backs of collars, suits and high heeled shoes, a Scandinavian couple wearing sandals and cagoules.

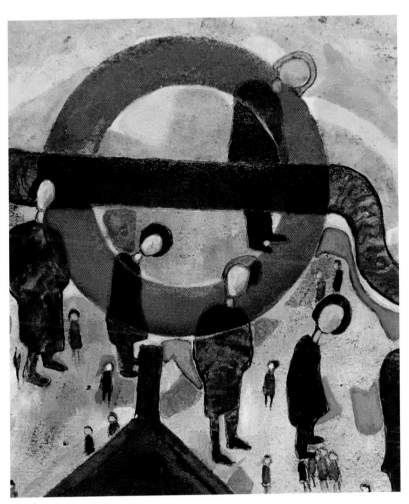

London Commute

Bowels of the labyrinth

Within the bowels of the labyrinth the platform heaves
Waves of strangers pile up in frothy heaps.
"Move down the platform" the conductor pleads,
though few take heed.

Out of the tunnel, bright as cats eyes,
the train comes, red and white,
drawing up, cheek to cheek
I listen to the sound of the slide of the doors
Before I pause to draw my breath
and step inside that tangled crush of arms, heads and legs
I've seen worse than this
Though there's scarcely room to breathe.
Then we all become subsumed within the tunnel

Two voices rise up above the rest,
Aggressive and male
eyes transfixed,
as expletives explode like hand grenades tossed
with hate in their bones,
spitting threats of scorn
as eyes of lightning strike.

Within this sardine city
a perceived infringement I suppose
Some kind of slight that bruised an ego

Yet as quickly as lava erupts it cools back into stony silence.
Whatever happened here, the moment has gone and barely a
ripple remains.

I can see them now, one middle aged,
the other hipper, cooler, a city type,
unavoidably close.
They gaze anywhere but each other's eyes
For there they know only demons lie.

WALK TO THE LEFT
STAND TO THE RIGHT
AND HOLD THE HAND RAIL

WALK TO THE LEFT
STAND TO THE RIGHT
AND HOLD THE HAND RAIL

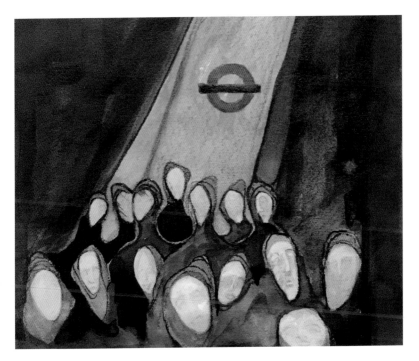

And still they come

The Void

I look down only to see my dull shoes in desperate need of a shine. I must remember to shine my shoes. However, this evening I will arrive home thinking of other things. I will take off my shoes and put them away whilst still thinking of other things. It will only be tomorrow, around about the same time, whilst sitting on the tube, that I will look down again and notice that my shoes are in desperate need of a shine.

Time Out

A girl opposite smiles to herself. On the front cover of her Time Out magazine it reads 'Secrets of the Tube'.

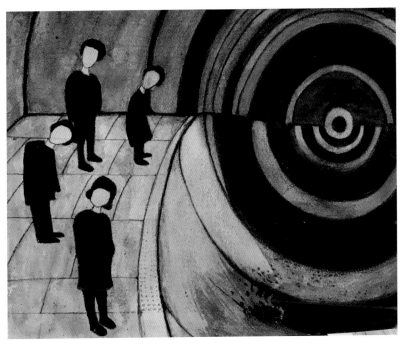

The Void

Amongst the Echoes

On occasions I've crossed the bridge,
weaved through the crowd
between the beggars, buskers and photograph takers.
Passing the skate boarders down by the arches
where the books are sold

Yet today people are few
and those few are wrapped up in coats and scarves
no hands are held and no one dallies
For a storm has passed.
The ground still wet with rain

I take the steps down to
Where the sand has been whipped up into drifts of pale and loose
grain
close by the waterline the sand becomes smooth as if darkened
snow
I tread thick and deep as each step left is hollow

From the river
I see distant commuters
streaming over bridges like ants over sticks
as daylight thins and the tide stays out,
further than I have ever seen before.

Amongst the sand and mud
lie flint, tiles and nails,
encrusted padlocks,
broken pots and delftware,
slim pale stems of pipes,
blue and white and salt glazed shards

the flowing combed lines of slipware,
honeyed and glistening

I look up
I am not alone as I had thought,
For in the gloaming light
I see another soul who stands much like me,
a silhouette in human form.
A ghost maybe
amongst these echoes

Gone are the pottery kilns that dotted the shore,
gone are the barges and the rust coloured sails,
and behind the grey clouds the Sun has gone too,
only the wind remains
and these ruins that lie within this lonely place
where all things must pass.

Before I leave I look down
And see nestled in the ground the pale curve of stoneware.
I feel for sharpened edges,

but it is smooth around the base and again around the rim.
Removed from its grave it lies
Exposed, muddied and perfect
save for a mark left by the thumb of its maker.
Fired clay became his flesh
And glaze became his skin
Across all these years
we find our connection.

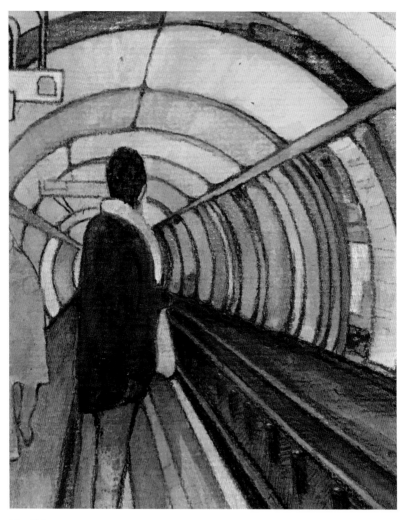

The Echo

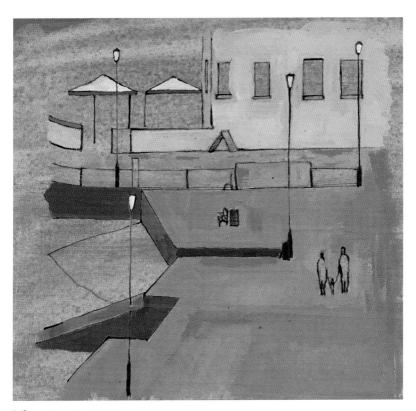

When you were young

Whispers on the Stones

The figure I saw along the Thames foreshore was a tall
drooping man, carelessly dressed and remote. When he
drew up closer he didn't look up to see me nod despite
there being no other soul in sight. I was readied to say good
evening but he was preoccupied, whispering his way over
the wet stones.

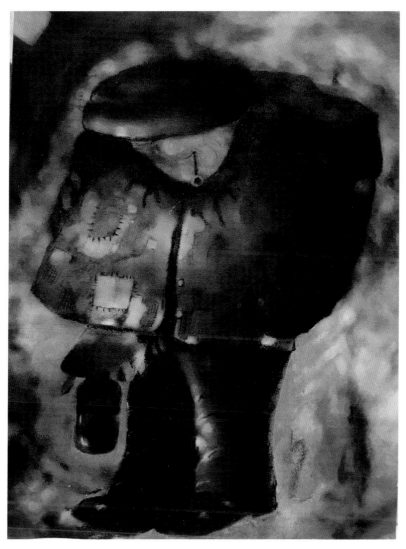

Bottle man

Loneliness

In our loneliness
we are not alone
If you look hard enough
you will see there are many
not just those stooped and quiet
but others amongst the crowd,
behind loud voices and flashing smiles
behind bright coloured clothes, suits and ties
Inside it's all the same
like an empty room,
a solitary chair
if you don't feel it now, well you will soon
for it is the way of things, our condition
best not to expect anything else
scooped up as we are within our skin,
for what keeps us together separates us too
the impermeable membrane
beyond which we will never know

yet it is all we have
so pause and take solace
just to know that in our loneliness
we really are not alone

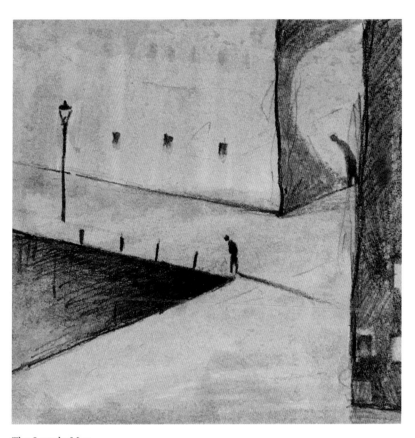

The Lonely Man

Fatality on the Tracks

The information boards are a full house of cancelled and delayed trains and the atmosphere layered heavy with bellowed announcements of 'fatality on the tracks'. The words seem to lose shape and meaning, becoming instead just a category of delay, like 'speed restrictions between Clapham Junction and Waterloo' or 'signal problems at Surbiton'. The commuters groan, all of us tired just wanting home. The mutterings and murmurings build as meagre options are gloomily picked over as the crowd swells with others arriving into this dismal place. The oppressive intensity grows until I can no longer stay in here, I have to go. I escape Waterloo and find myself now in the hushed murmours of the Festival Hall, settled at a table with a neat coffee, feeling quite sophisticated and cultured simply by virtue of being in such close proximity to so many cultural types. They walk about in jazzy shirts with their hair quaffed, green and blue, each of them special. I see sculpted beards, sleek ipads, small leather bags and shoes without socks. I feel a bit out of place so I take off my anorak. The coffee is drained down to the last cold dregs. 'Fatality on the tracks'. I wonder who they were, how did their last day begin, did they know it was to be their last? Perhaps the decision to bring their life to a close had brought a cold comfort to know the suffering would end. Crushed by the past and paralysed by the present. They could see no future. The meaninglessness of life, the complexity, the atomization, the loneliness and alienation, cast adrift on an anonymous sea of online forms, passwords, logins, internet connected disconnection, distanced from everything tangible, earthy and solid. No longer being 'seen'. The emptiness of being let down by others, of taking wrong choices, of never having had a chance, the regrets and a thousand watching eyes who scrutinise, waiting for them to fail. They tried and it was useless. Nothing ever worked.

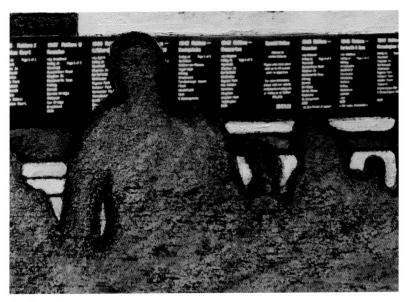

Platform Six

Waterloo

Waterloo, this cathedral space,
majestical in its vastness where people come only to leave.
As a child this was London,
as a man it is where I am dumped out day after day from the
incoming conveyer belts,
and all around me are the commuters in their clocklike routines,
controlled by the ticking minutes that dictate our lives,
that thrust upon us unasked for familiarities.
There is the Evening Standard stall,
there is the card shop,
there are the sloping escalators
here is the thronging crowd programmed like me, head down, no
time to stop.

The journeys are laid down like silt,
fine upon the ocean floor,
solidifing over time into moulds
and we become shaped within those moulds until one day you
forget who you once were.
What was it I wanted?
When I was a child what did I expect, was it this?
The days of midwinter play tricks and draw lines upon my face,
they pull and tug at my skin and at my soul.

I arrive early to open up a small crack in time.
I rise up to the gods of the balcony café and from there look down
upon the hordes below.
They gather in eddies,
standing like iron filings aligned by the magnetism of the
information boards.

From time to time a small herd breaks off,
rushing to the gates where the scrum filters into single file and
heads on through to the platforms and trains.
There is a restless movement,
the sound of humans, black coated like bats.

An old man who moves slower than the rest, leaning on his wheeled
support.

The overhead tannoy booms news of some train going someplace,
sometime soon.
An electrical wire hangs down from the roof space ending in a
coiled knot.
It swings gently, powered by the vibrations of trains, generators and
footsteps.
The heartbeat of the city,
quiet and slow it marks out our time.

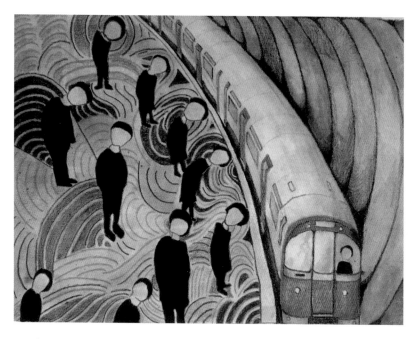

London Waterloo

Brexit, terrorism and Covid-19

Within Waterloo you are in the midst of it all, the busyness of the thronging crowds. But there is always something else going on, some kind of backdrop or context to all our journeys. The issue of the day that permeates into our minds, filling the newspaper columns, podcasts and online news. Differing, bickering and outraged views on both sides all thinking they know best with no need to listen. The fear of the 'other' with explosive vests, long beards and rucksack wearers eventually morphed into the fear of each other, the fear of a cough. Wearing a mask changed from being an odd thing to becoming the social norm. Social distancing at two metres also became the norm, avoiding touching, alcohol gels and wet wipes for the hands. The commute becomes a thing of danger for one reason or another. What I wonder will be next.

Wanting to be a better person

I missed my train even though I saw it. I made it through the gates and almost touched it. I cursed it but still it left me alone on the platform. Back again in the standing crowd, everything begins to drain, the hunger and weary bones crush me and all my power fades and empties. I begin to think a bar of chocolate might help. But I resist resolutely. Indeed so well do I resist that I begin to contemplate rewarding myself with something like a bar of chocolate. My mind can work like that sometimes so I have to watch out for my own slippery ways. But I do need something. If not

chocolate then what else could fill that inner void that sits inside like a ravenous black hole. Maybe a book from the bookshop. Not any book but a beautiful book whose design and contents offer to impart meaning, understanding or some kind of profundity. I want to be someone other than this harrassed middle aged man caught up in this incessant rat wheel routine, waiting impatiently for the 19.12. I need to become a better version of myself somehow. In the bookshop I gaze at the long rows of crisp cut books sitting along the shelves. I seem to know so little about so many things, where do you even start? It feels hopeless. I chance upon a book by Rami the poet. This is it, exactly the kind of book I had in mind, one I would not usually buy and all the better for it as I need new insight, a different angle, a wisdom from a different source. Book in hand I march over to the cash desk. The intellectual looking, bespectacled, blue stocking wearing bookshop assistant will be suitably impressed I should imagine. However, as it happens she scans and bags up the book with a ruthless speed and efficiency without even passing a glance at either me or 'the book'. Nevertheless, by virtue of buying such an interesting book that surely means I am now on the brink of becoming an interesting type of person, the wise learned type, the type I want to be. I suppose I need to do some reading.

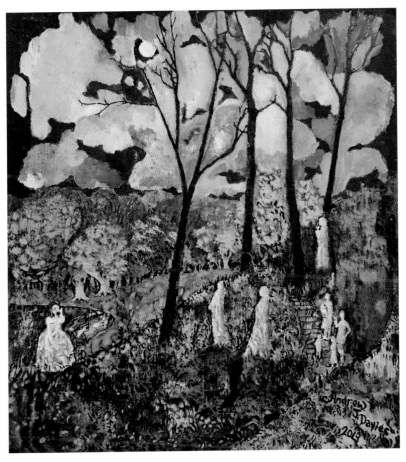

The Watchers

Waiting to go

Sitting in the train in the station the seats slowly fill up. A man close to me mutters "Christ" underneath his breath for no reason that I can see until a woman arrives in her sixties. She bounces in and booms "HiyaTony! Whatta the chances! My God! Hey, you don't mind if I plonk myself down? Room for a little one". Caught like a rabbit in headlights Tony has nowhere to run so instead he smiles obediently as if he is pleased to see her as she makes herself at home next to him.

In those minutes of waiting a roulette wheel spins as to who might come along and sit next to you for the journey. I always hold out a small hope that perhaps no one will come but they always do of course, sometimes taking half my seat. Whilst I don't invite anyone to sit next to me I do at least play the game fairly unlike the woman opposite who leaves her bag on the vacant seat with the sole purpose of putting off people from sitting there. Annoyingly it works as someone comes only to hesitate and choose instead to take the seat next to me rather than her. I almost admire her masterful timing when she feigned to move her bag the very instant she knew the person had committed to the decision to sit next to me. Not only does she keep the space but the newcomer actually smiles at her in appreciation of her 'kindness' of being prepared to move her bag. I almost feel moved to explain that this is no more than a scam, it is a façade, there is no 'nicey nicey' here only the workings of a seasoned commuter who has marked out her territory and is prepared to fight dirty.

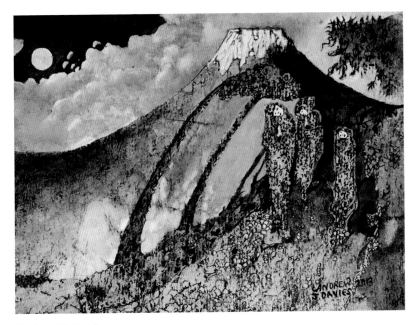

On the Silk Road

The 19.12 pulls away

Barely a nudge, less than a push
imperceptibly at first
the 19.12 pulls away slowly
rolling past columns,
past a woman wheeling her bag and a man stooped to tie his shoe,
beyond the end of the platform,
out to the parallel lines glinting silver in the sun
curling away from Waterloo.
The track side of the city
with dark brick walls,
the backs of buildings,
blocked out windows and warehouse doors.
industrial stains and tower blocks rise
empty, boarded, graffiti sprawled,
not out of place in this hinterland
where rundrels sprout by the trackside.
We skim at the height of rooftops
skipping over city streets,
newly released,
gathering pace,
over the bridge,
finding rhythm.

The Return Journey

Stairwells (The tower block)

Into the evening beneath greyware skies,
past the hulks of buildings twenty stories high,
where the line curls round,
pulled in by the shadows,
where the blackness is broken
only by the stairwells,
climbing high in columns of lambent light,
cloaked in the darkness of a frozen night.
I have never stood upon those stairs,
their echoing spaces, the cool night air.
The reinforced glass and the wire mesh within,
the long corridors that trace out the rim.

Across this city and through the night
the train flies out of sight of the thousand souls that live within,
as close and as far as the furthest star,
we are the passing strangers.

The Conductor

We hear his voice on leaving Waterloo, warm and old, like a fading colour, a reassuring rug, a favorite slipper for our souls. He is one of the good conductors if for no other reason than his voice. "Good evening I am Bob Winrow your conductor for this evening's journey, I will be walking through the carriages at various points of the journey. I am currently located at the rear of this eight coach train. As I walk through the carriages I am able to offer you tickets for today but I am also able to sell you tickets for the coming week, I am also able to renew weekly or monthly tickets. This is the 19.12 to Basingstoke, expected time of arrival at Basingstoke is 20.16 that's...... 8.16. First stop Woking...thank youp".

There is a shriek of delight from the conductor, not Bob Winrow but another "Where do you think you are going?!" he asks gleefully. I can't hear her mumbled reply but I hear him again "Oh no you're not, this train doesn't stop at Clapham Junction, didn't you hear me?! Thats what comes of these headphones stuck in everyone's ears these days! Dear oh dear oh dear oh dearie me. You'll have to go to Woking, change there and then you'll have to come ALL the way back. You won't be doing that again will you!" He bounces on down the carriage with quite a spring to his step. It seems as if it is little moments like this that make it all worthwhile for him.

I rest my head upon the window, my eyes heavy in the lazy warm glow of the sepia Sun, the train gently lulls and the air conditioner softly hums a lullaby. Outside a blur of green passes by as the conductor comes with his hair receded right back to a last rearguard action somewhere on the back of his head. He announces something unintelligible and so it wakes me up to listen again, "Shebeebies" he seems to say. He says it again in an official way "Shebeebies". He says

it to me "Shebeebies" and I show him my ticket, which he seems happy with, nodding solemnly before he carries on. "Shebeebies". I later translated it to "tickets please".

"Please note that Oyster and non-contact payment cards are not valid beyond the next station."

"The next stop is Surbiton. Change here for Thames Ditton and Hampton Court".

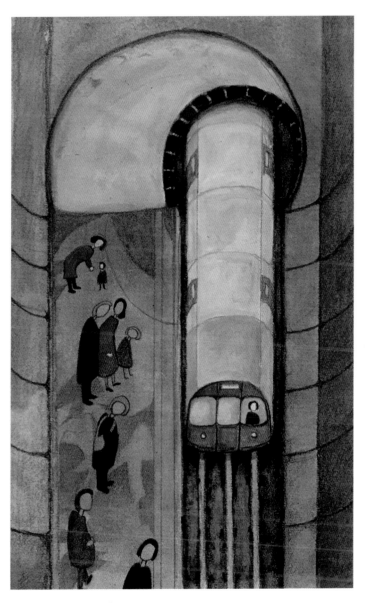

Sunday morning tube

A Breeze passes through

A breeze passes through
raising barely a breath
beyond the end of the platform
to where our carriage has come to a rest
no more than a stone's throw,
becalmed beneath the late sun
it is as if the world ceases to turn
and a trance has befallen the earth
I place my book down and lean my head upon the glass.
All that moves are the ripples of leaves
and the bowed heads of meadow grass
sprouting between the sleepers and the rusted rail.
Within this peace the conductor comes with the news
There is a body on the line
just beneath the bridge,
just up ahead.

Pursued

We are a pursued people. Pursued even here on the train. Hounded for our attention by emails, phone calls, laptops, Whatsapp and text exchange. We carry our work with us all the time, it is there in our pocket just a click away, always in our mind. Always that feeling that perhaps I should just check again and keep ahead of the game.

Woking Again

A retired group from the shires have visited an art gallery. A slice of culture to mention to the neighbours at the weekend. "We were lucky with the weather" says Maureen. Audrey agrees. The two husbands, Giles and Nicholas, remain silent. They have guide books of the show at the RA. "How's Polly's new job?" asks Audrey. Maureen is about to reply but yelps instead "Oh Giles, there's a wasp, a wasp, get it, GET IT". Giles swings into action, ex-army, I should think, grabbing his moment and grabbing the RA book and swatting about with firm swipes as if there there was a method to this wasp hitting pursuit. He nearly hits Maureen on the nose. The wasp flies off with its life intact and doesn't come back.

At Woking a man in his fifties clomps past in cycling shoes, his cycling helmet resembling a space craft as he clings to youth just as tightly as the lycra clings to him. A hoodied man boards and briefly stands overwhelmed by the choice of seats. He settles in the end by the window and opens his book, folding it back upon its spine.

Purpose

I can see in through the café window. Lamps hang low from the ceiling creating pools of light on the tables. Silhouetted customers sit bent over coffees. Behind the counter, up on the wall is written the line 'Fall in love again'. We are nothing if we have no love for it is what binds us and gives our lives purpose. If it has been lost it must be found again even if it takes on a different form.

Conversation I

A woman on the phone some way behind my head "Yes... yes, she definitely saw me but just walked right passed! Would you believe it? She snubbed me the bitch!. Her with her flat arse and daggy hair".

Conversation II

Another voice: "You can use the chicken nuggets, they're in the freezer. The ones from Saturday. Yes, they'll be fine, ok love, ok then, put them on the side and I'll do the nuggets".

Conversation III

The woman opposite me settled in at Waterloo. Not the typical commuter type. When she arrived, she brought with her the stale odour of alcohol and was quick to open up another can. Black furred boots, red torn tights, short shorts and legs placed to accommodate her luggage. Pieces of metal looped through lipsticked lips and another ring through her nose. The benefits of youth have passed, her features plain, though her clothes and the alternative bits of metal studded about her skin set her apart. In the quiet zone she answers her phone loud and unconcerned, conversing in a language unknown to me other than the liberal use of English obscenities. She had removed her earphones to help her speak and thus shared the rock music that had already seemed loud even when plugged in her ears. She leaned forward at one point to speak to me. Despite all the noise and drama I viewed her with tolerant eyes. I could sense the tremors of a troubled mind. She wondered if we had passed Bermondsey. "Bermondsey?" I queried. She corrected herself, "Basingstoke". I reassured her that this train terminates at Basingstoke, and so could not fail to miss it. Reassured she smiled and thanked me. I smiled too and that was all.

Conversations sift

The train runs smooth, almost humming.
Evening has come and the Sun is missing,
Lost amongst bridges, clouds and buildings.
The rippled light stained sky,
grey and fading traces

We are squeezed between strangers
neither solution nor precipitation
only the day's residue remains
in this liminal place that is neither here nor there
where our bodies and souls can breathe
where murmured voices merge
with rustled papers and conversations that sift in and out of silence,
seeking the truth yet there no longer is truth

Some tune into screens
others just listen,
head back, eyes closed waiting for home.
Some think of chores,
trying to recall
which bin to put out

Phone watchers scroll, Newspaper readers read,
magazine gazers gaze the gloss of celebrity lives,
the romances and breakups,
the bikini shots, tummy tucks and botox,
it's all here the hopes and fears,
love and loss,
all grist to the mill
so ends another day

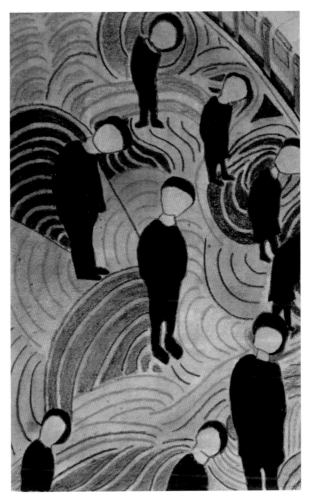

Nameless Traveller

Carry us home

Outside night has fallen and a gibbous Moon breaks through shredded clouds. The crowd has thinned and the red seats are almost empty. In Fleet station two people sit on benches in a shelter, a dim glow of light falls upon them, lighting up faces just enough to show cheek bones and noses. It could be 1940 or any other year as time distorts and meaning is lost.

The journey is not just a physical one but a felt one. Entombed within our corporeal selves, within this carriage, our minds roam free, picking through the debris, reliving the past, reviewing what was said, cringing at comments spoken and those left unsaid. These echoes maybe sad, good or wholly bad as they shift in and out of focus but all the time the train moves on.

I sit here, amongst my people, my fellow strangers, my kin and the empty seats are those who have passed before. We have little more to give today, we have done all we can, tomorrow will start anew and until then we trust the train to carry us home.

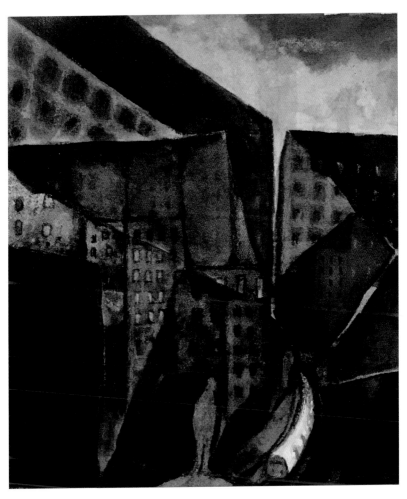

Urban Landscape

21 steps

Once on the platform his stick sweeps in wide arcs
feeling his way rhythmically within his dark,
until he reaches the bridge.
Upon which he ascends
with a surety of foot,
until he hits the flat span
seeking out another step.

Though usually room for two,
he sways gently, his oscillations sweeping wider still
I fall in behind and match his pace.
I think of the sounds he hears
of footsteps, trouser legs and coats.
A word or two of conversation,
a cough, a cold, the clearing of a throat.
The sense of people returning

He runs his finger along the cast iron wall
All the way,
over rivets, roughened edges and worn out paint,
until it slips off into thin air
the signal to descend
down to the left.
Twenty-one steps
nearly there

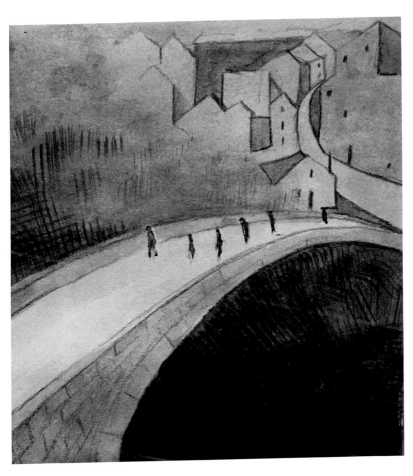

Nearly There

The gleaming eye

Out of the darkness
comes the gleaming eye,
the express train,
a needle through the night,
threading beneath bridges, across distances,
diminished now to nothing

Those of us caught here upon this bridge,
feel the rolling thunder,
the driving violence
the distorted air,
that pulls our souls
to the shadows beneath
where death roams

We flinch and want to hold on
we mutter and curse,
each of us mortal fragile flesh,
defenseless against this monster

But it is gone,
tracing away into the void
leaving us alone,
so when we reach the other side.
Death has passed
And we thank our Gods we are still alive.

The Express

Earthen Tones Publications